For the Masterjohn family
and for the members of my parish,
the Saint Nicholas Orthodox Church
in Worcester, Massachusetts

First Edition

Library of Congress Cataloging-in-Publication Data

Bible. N.T. Matthew. English. Revised Standard. Selections.
 1993.
 The Nativity : from the Gospels of Matthew and Luke / illustrated
by Ruth Sanderson. — 1st ed.
 p. cm.
 Summary: An illustrated version of the birth of Jesus Christ,
taken from the Gospels of Matthew and Luke.
 ISBN 0-316-77064-7
 1. Jesus Christ — Nativity — Art. [1. Jesus Christ — Nativity.]
I. Sanderson, Ruth, ill. II. Bible. N.T. Luke. English. Revised
Standard. Selections. 1993. III. Title.
BT315.A3 1993
232.92 — dc20 92-9071

10 9 8 7 6 5 4 3 2

HR

Published simultaneously in Canada
by Little, Brown & Company (Canada) Limited

Printed in the United States of America

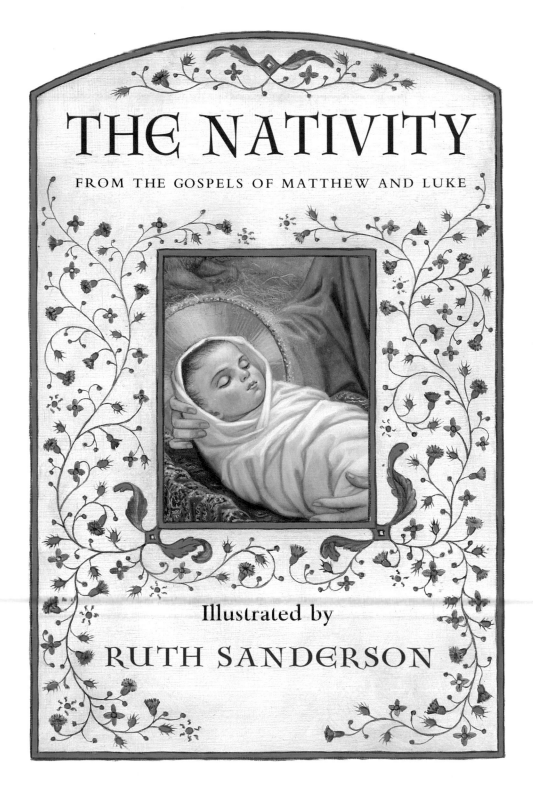

THE NATIVITY

FROM THE GOSPELS OF MATTHEW AND LUKE

Illustrated by

RUTH SANDERSON

Little, Brown and Company

Boston New York Toronto London

And in the sixth month, the angel Gabriel was sent from God to a city of Galilee named Nazareth, to a virgin betrothed to a man whose name was Joseph, of the house of David; and the virgin's name was Mary. And the angel came to her and said, "Hail, O favored one, the Lord is with you!" But she was greatly troubled at the saying, and considered in her mind what sort of greeting this might be. And the angel said to her, "Do not be afraid, Mary, for you have found favor with God. And behold, you will conceive in your womb and bear a son, and you shall call his name Jesus.

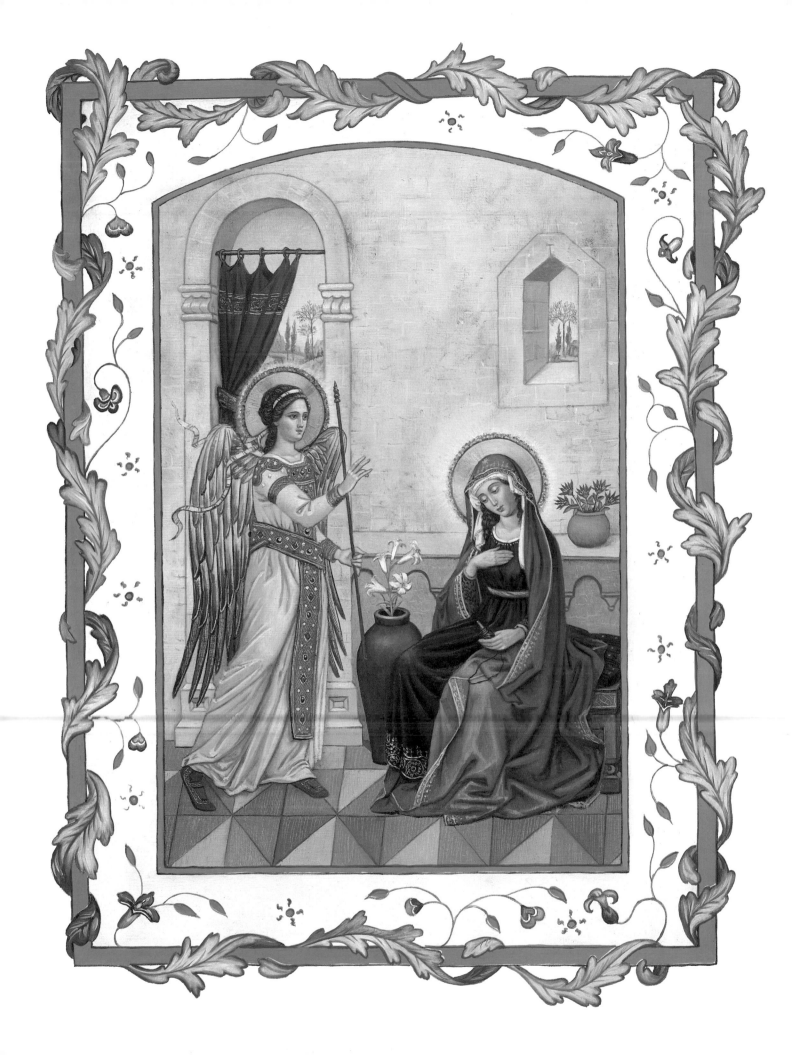

He will be great, and will be called the Son of the Most High; and the Lord God will give to him the throne of his father, David, and he will reign over the house of Jacob forever; and of his kingdom there will be no end."

And Mary said to the angel, "How shall this be, since I have no husband?"

And the angel said to her, "The Holy Spirit will come upon you, and the power of the Most High will overshadow you; therefore the child to be born will be called holy, the Son of God."

And Mary said, "Behold, I am the handmaid of the Lord; let it be to me according to your word." And the angel departed from her.

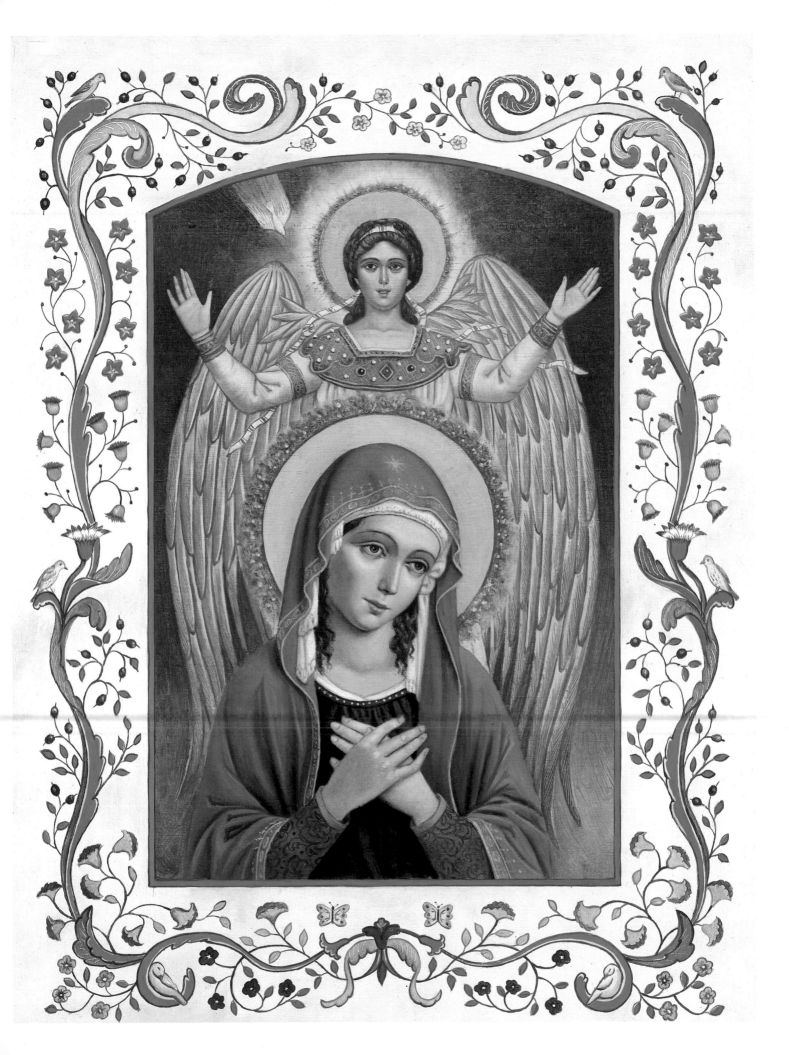

In those days a decree went out from Caesar Augustus that all the world should be enrolled. And all went to be enrolled, each to his own city. And Joseph also went up from Galilee, from the city of Nazareth, to Judea, to the city of David, which is called Bethlehem, because he was of the house and lineage of David, to be enrolled with Mary, his betrothed, who was with child.

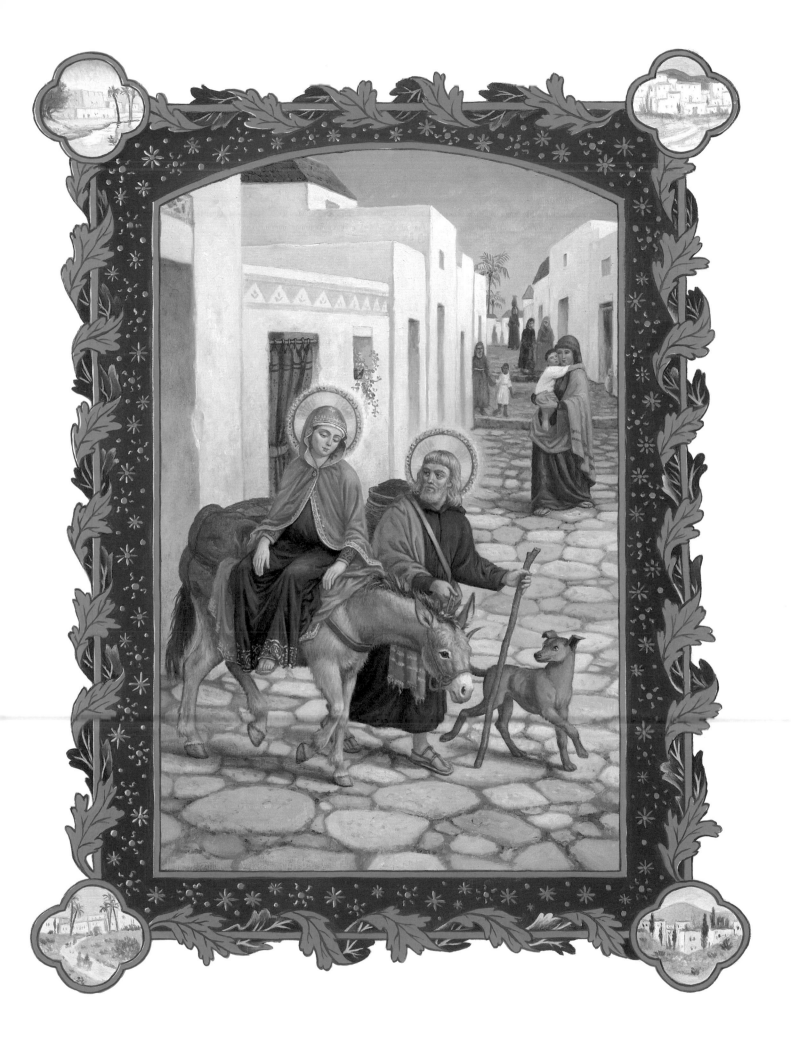

And while they were there, the time came for her to be delivered. And she gave birth to her first-born son and wrapped him in swaddling cloths, and laid him in a manger, because there was no place for them in the inn.

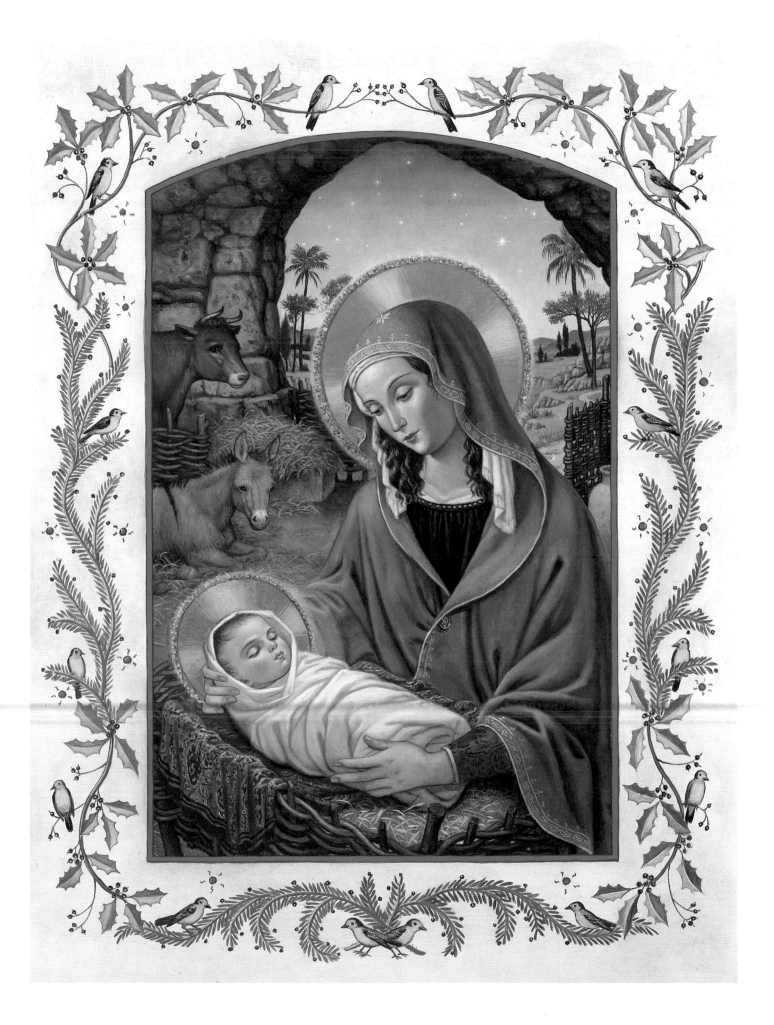

And in that region there were shepherds out in the field, keeping watch over their flock by night. And an angel of the Lord appeared to them, and the glory of the Lord shone around them, and they were filled with fear. And the angel said to them, "Be not afraid; for behold, I bring you good news of a great joy which will come to all the people; for to you is born this day in the city of David a Savior, who is Christ the Lord. And this will be a sign for you: you will find a babe wrapped in swaddling cloths and lying in a manger."

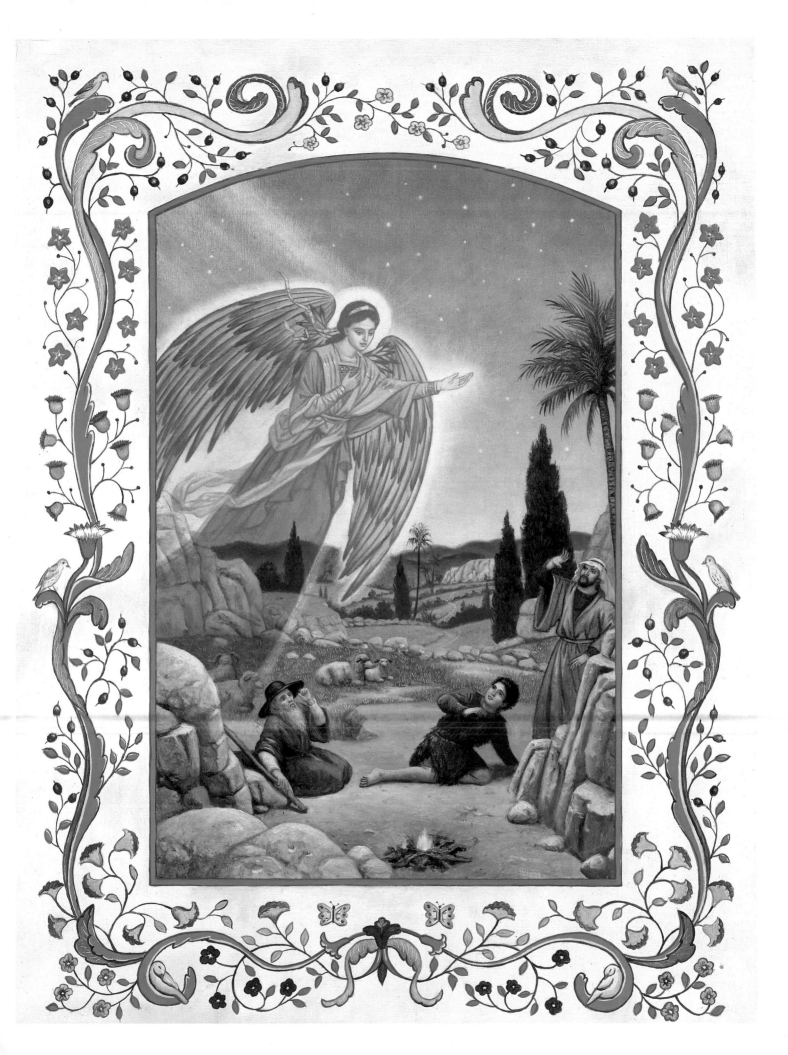

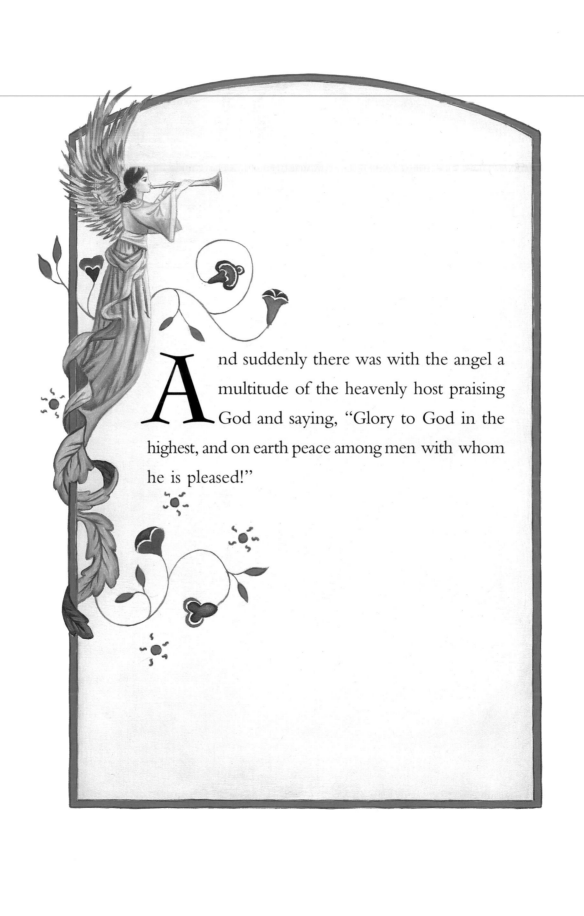

And suddenly there was with the angel a multitude of the heavenly host praising God and saying, "Glory to God in the highest, and on earth peace among men with whom he is pleased!"

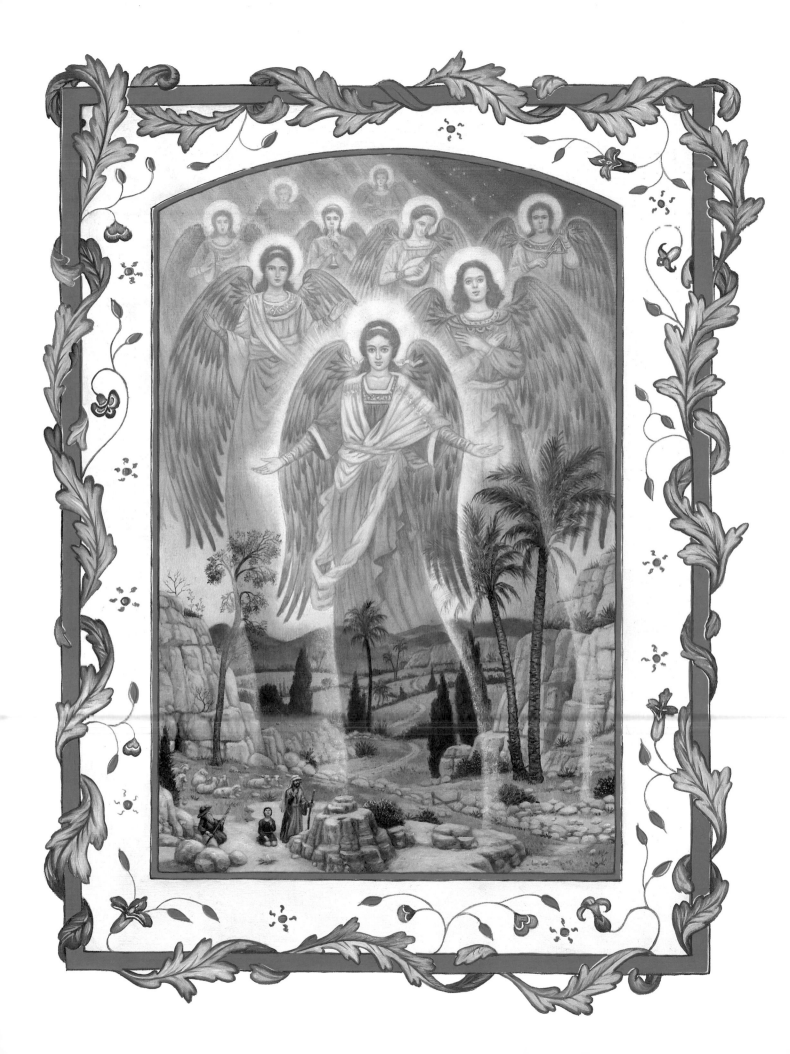

When the angels went away from them into heaven, the shepherds said to one another, "Let us go over to Bethlehem and see this thing that has happened, which the Lord has made known to us." And they went with haste, and found Mary and Joseph, and the babe lying in a manger. And when they saw it, they made known the saying which had been told them concerning this child; and all who heard it wondered at what the shepherds told them. But Mary kept all these things, pondering them in her heart.

And the shepherds returned, glorifying and praising God for all they had heard and seen, as it had been told them.

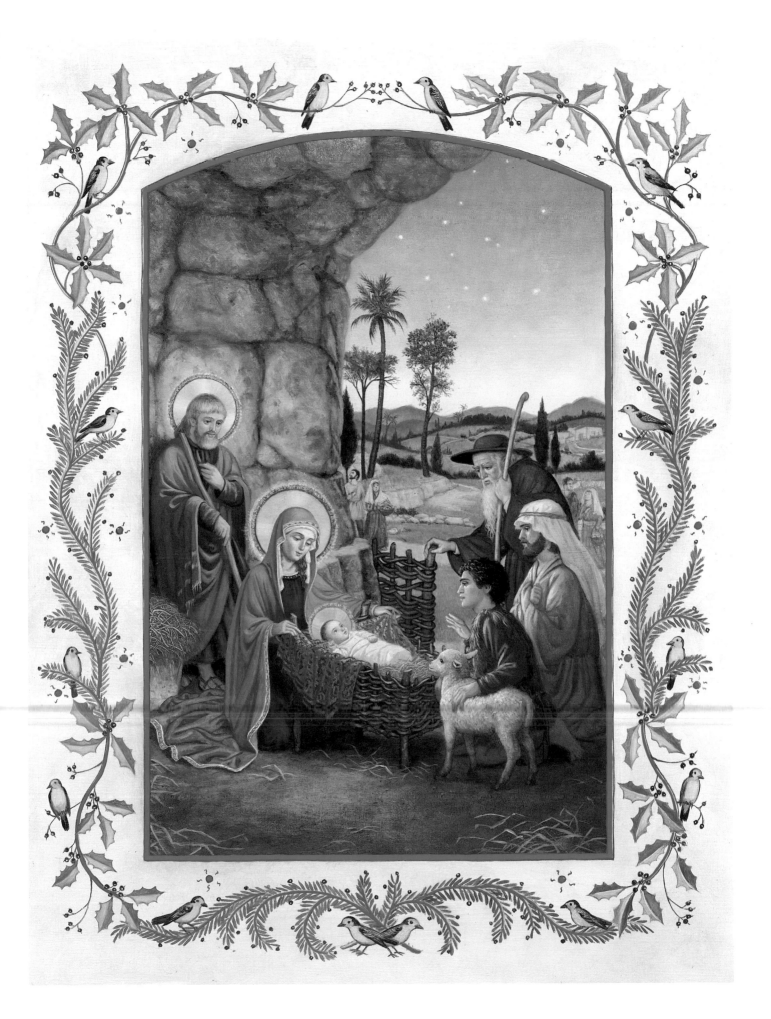

Now when Jesus was born in Bethlehem of Judea in the days of Herod the king, behold, wise men from the East came to Jerusalem, saying, "Where is he who has been born king of the Jews? For we have seen his star in the East, and have come to worship him." When Herod the king heard this, he was troubled, and all Jerusalem with him; and assembling all the chief priests and scribes of the people, he inquired of them where the Christ was to be born. They told him, "In Bethlehem of Judea, for so it is written by the prophet: 'And you, O Bethlehem, in the land of Judah, are by no means least among the rulers of Judah; for from you shall come a ruler who will govern my people Israel.' "

Then Herod summoned the wise men secretly and ascertained from them what time the star had appeared; and he sent them to Bethlehem, saying, "Go and search diligently for the child, and when you have found him, bring me word, that I too may come and worship him."

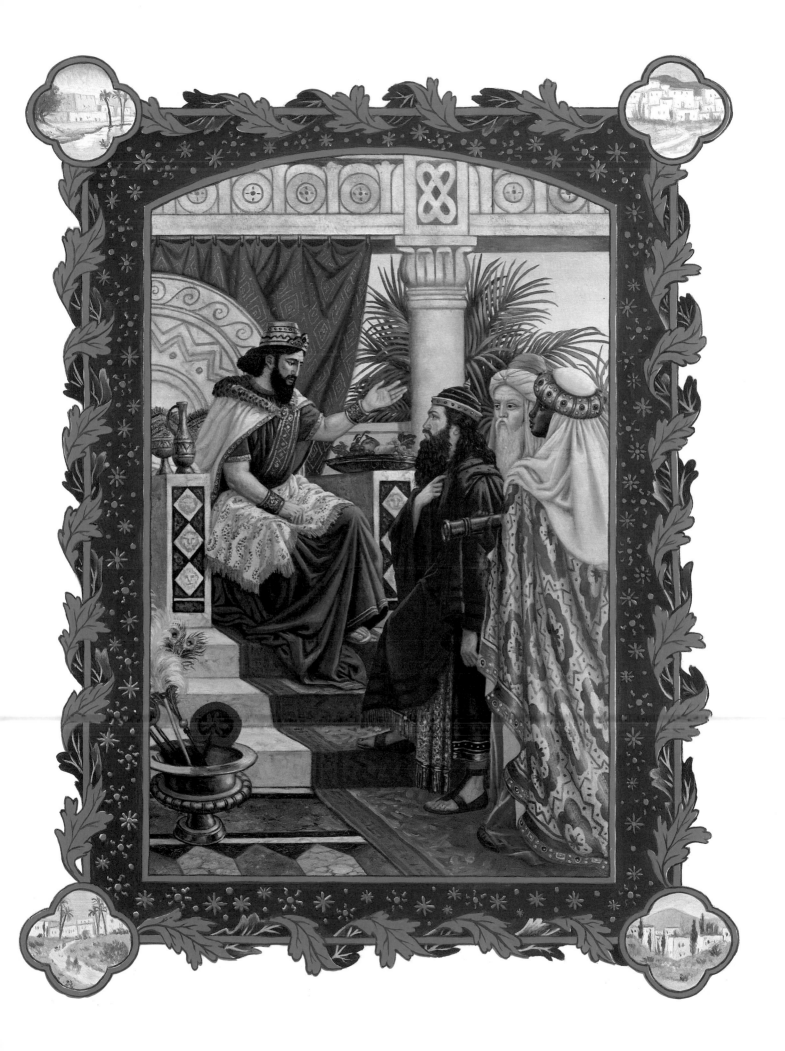

When they had heard the king, they went on their way; and lo, the star which they had seen in the East went before them, till it came to rest over the place where the child was. When they saw the star, they rejoiced exceedingly with great joy; and going to the house they saw the child with Mary, his mother, and they fell down and worshiped him. Then, opening their treasures, they offered him gifts: gold and frankincense and myrrh. And being warned in a dream not to return to Herod, they departed to their own country by another way.

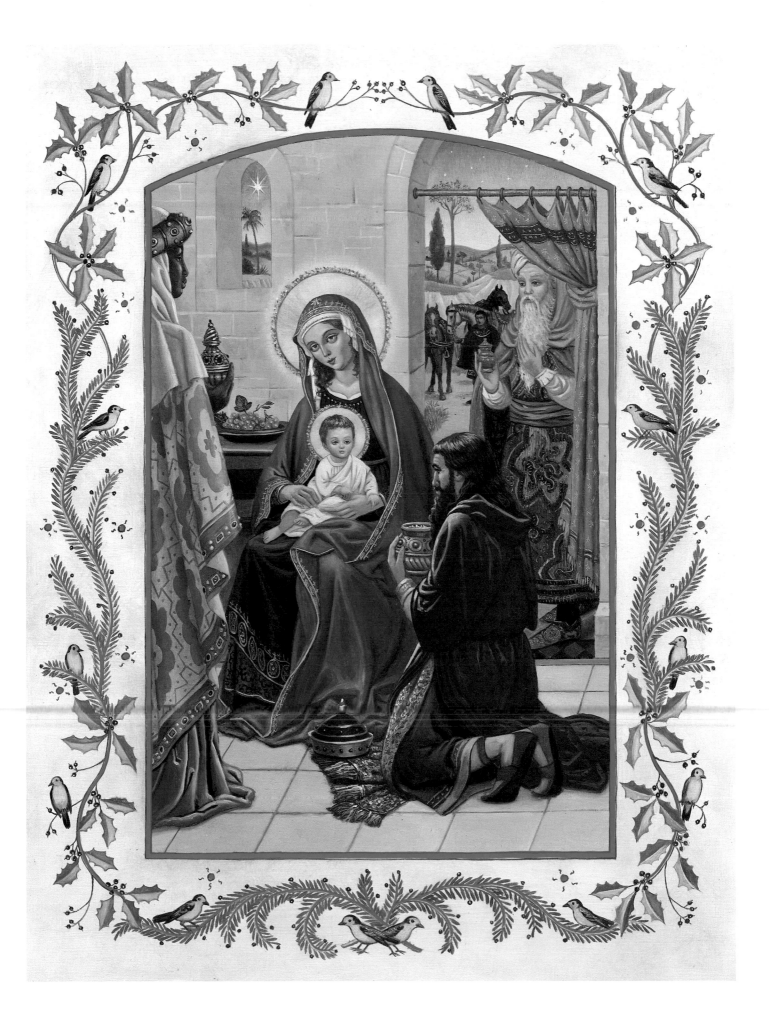

Now, when they had departed, behold, an angel of the Lord appeared to Joseph in a dream and said, "Rise, take the child and his mother, and flee to Egypt, and remain there till I tell you; for Herod is about to search for the child, to destroy him." And Joseph rose and took the child and his mother by night, and departed to Egypt, and remained there until the death of Herod.

Then Herod, when he saw that he had been tricked by the wise men, was in a furious rage, and he sent and killed all the male children in Bethlehem and all that region who were two years old or under, according to the time which he had ascertained from the wise men.

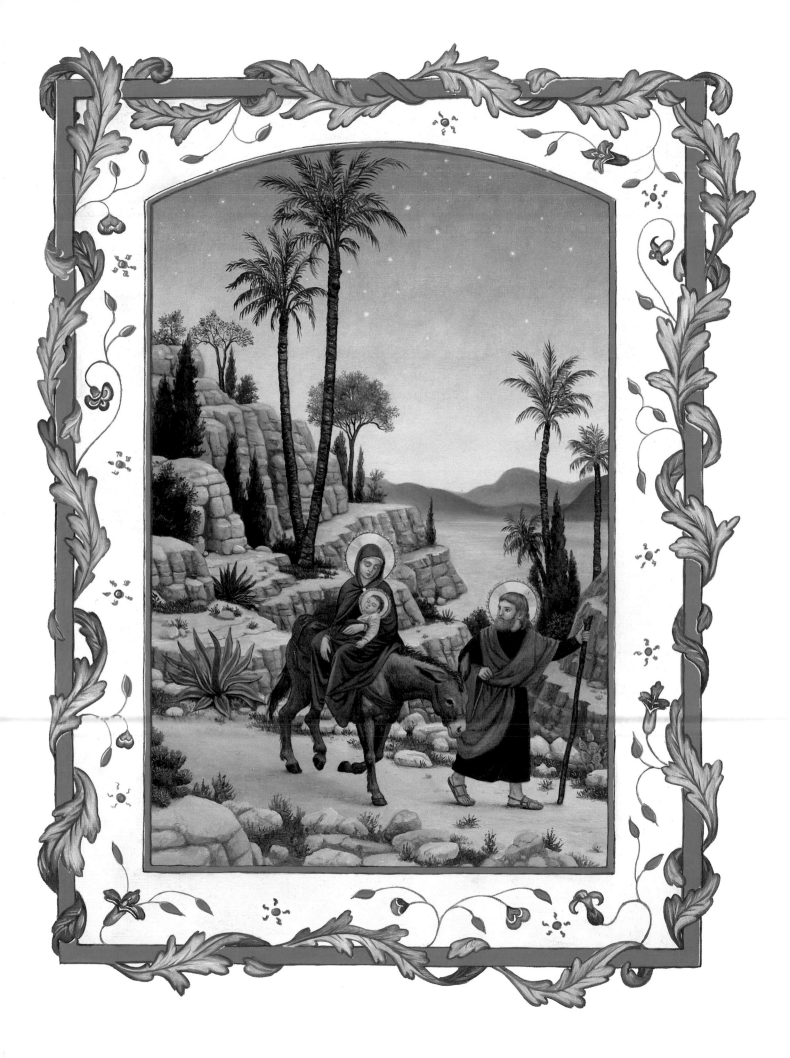

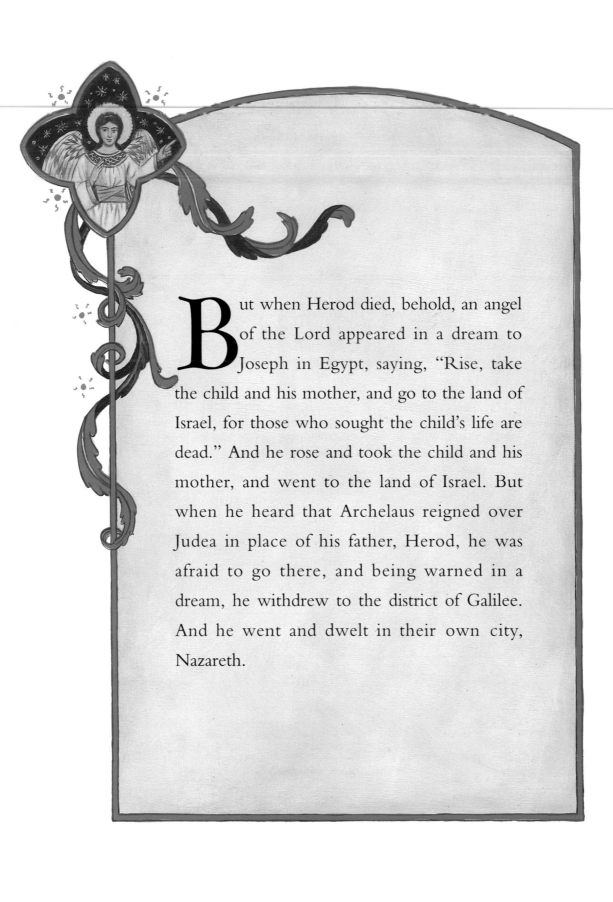

But when Herod died, behold, an angel of the Lord appeared in a dream to Joseph in Egypt, saying, "Rise, take the child and his mother, and go to the land of Israel, for those who sought the child's life are dead." And he rose and took the child and his mother, and went to the land of Israel. But when he heard that Archelaus reigned over Judea in place of his father, Herod, he was afraid to go there, and being warned in a dream, he withdrew to the district of Galilee. And he went and dwelt in their own city, Nazareth.

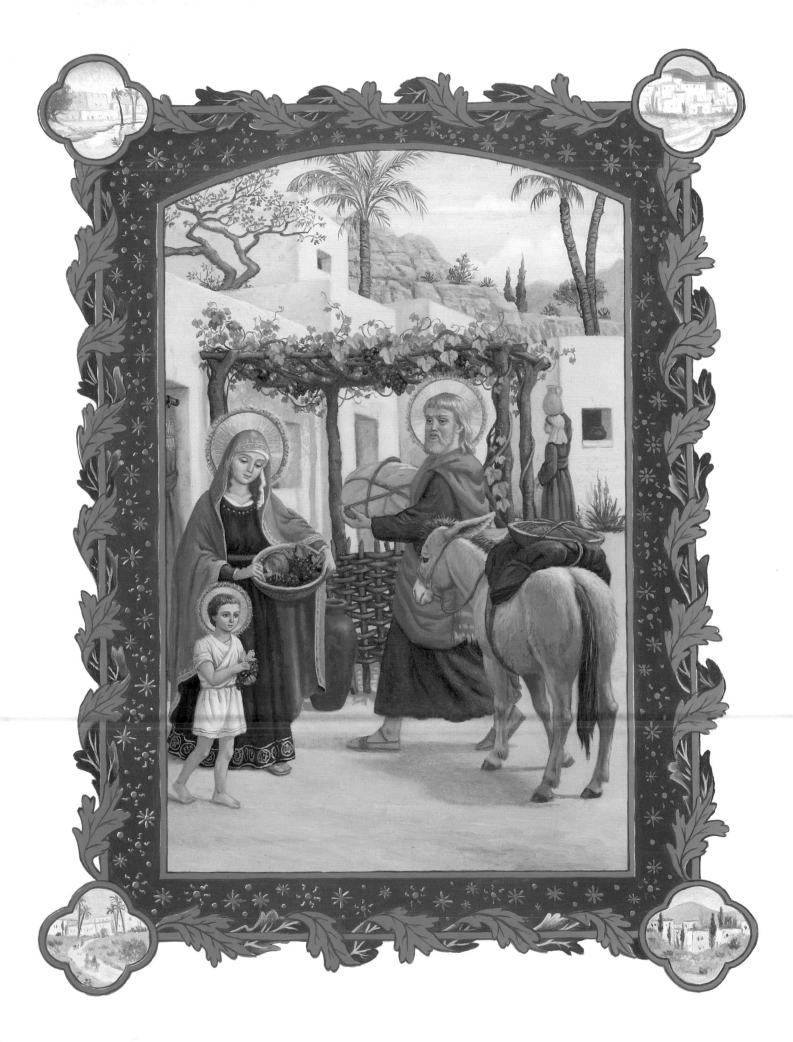

And the child grew and became strong, filled with wisdom; and the favor of God was upon him.

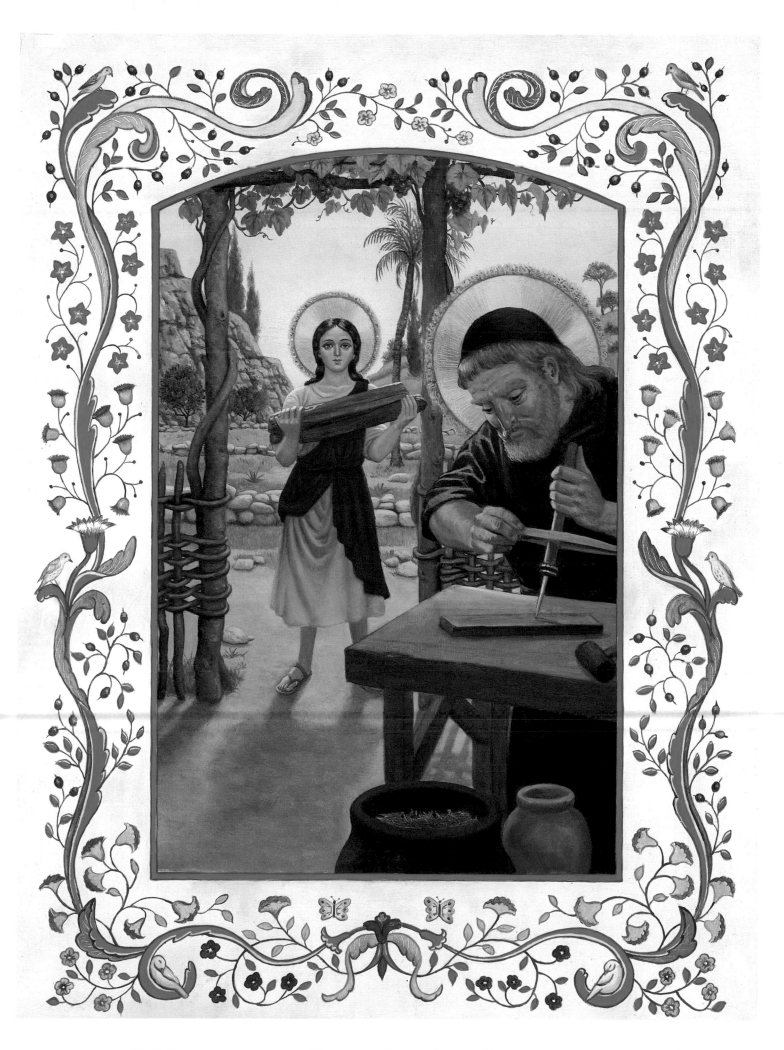